SLOTHILDA

LIVING THE SLOTH LIFE

DANTE FABIERO

Skyhorse Publishing

"HEREDITARY SLOTH INSTRUCTS ME."

—WILLIAM SHAKESPEARE

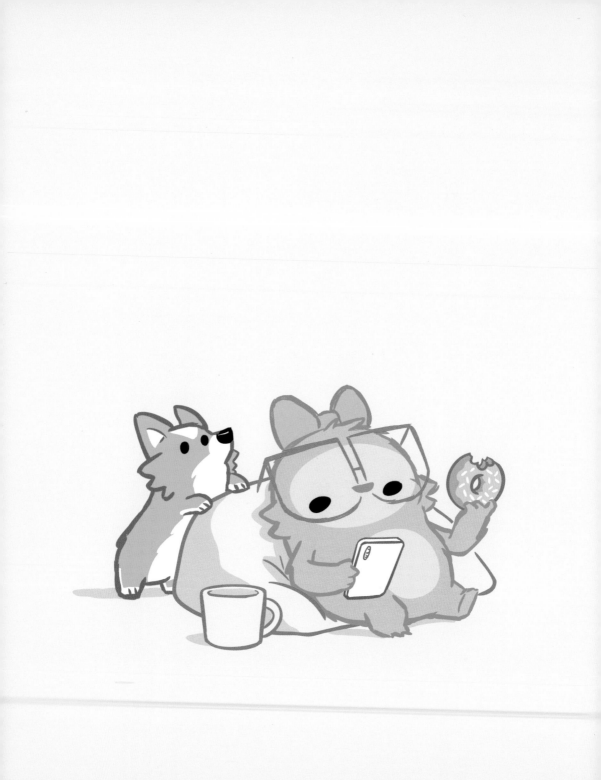

TABLE OF CONTENTS

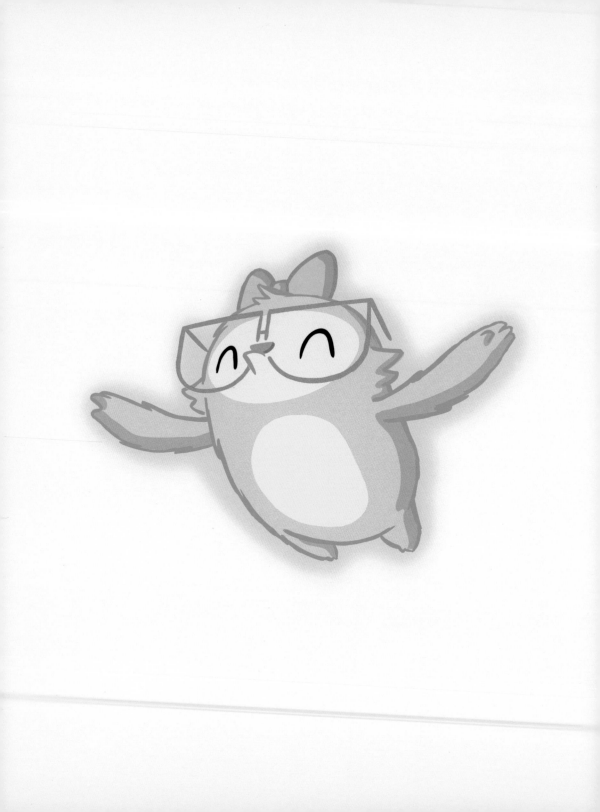

INTRODUCTION

Life's easy when you're a sloth . . . unless you've got responsibilities, goals, and high cholesterol. In that case, living the sloth life is a bit more challenging.

"I should go to the gym, but I'd rather take a nap."
"I should finish my work, but I wanna watch Netflix."
"I should eat kale and egg whites, but doughnuts are delicious."

These are all things I say to myself daily.

In 2014 I started a blog documenting my struggles with procrastination, laziness, and temptation. Seeing as my experiences were universally shared among friends, I wanted to tell jokes through a relatable cartoon character—a representation of the lazy spirit animal that lives inside us all. Thus, Slothilda was born—a sweet, imperfect, sleepy little sloth.

Slothilda turned into an online comic series about a relatable mascot who encounters obstacles as a sloth. Being innately lazy poses amusing challenges to her personal growth. She constantly struggles to overcome procrastination, her love for junk food, and her addiction to modern-day technology.

Sound familiar? In this book Slothilda explores an inner conflict we can all relate to—the desire to succeed and grow, while paradoxically dealing with the ever present temptation to sloth.

In reality being a sloth is part of life—and sometimes, the most enjoyable part of life. So next time you're tempted to indulge in a bout of binge watching, Internet-surfing, and couch potato-ing . . . don't feel bad. Embrace your inner Slothilda!

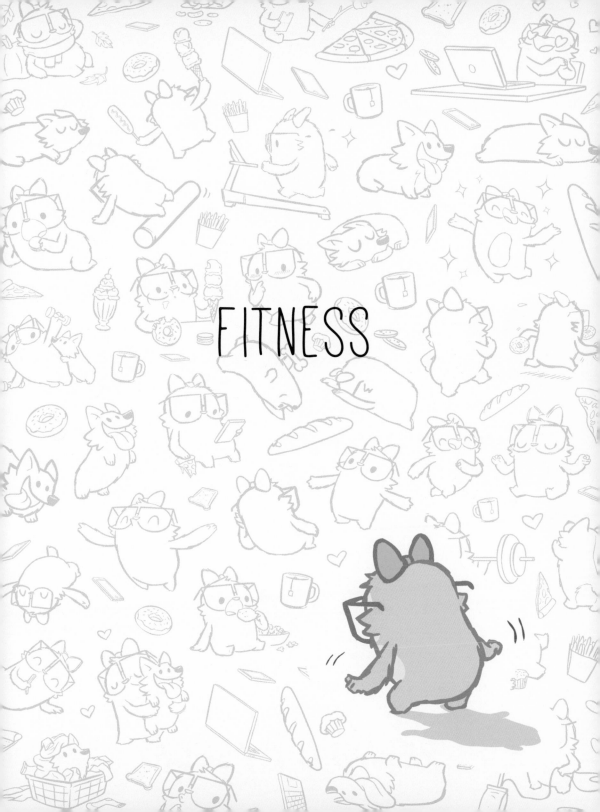

FITNESS

THE FITNESS CYCLE

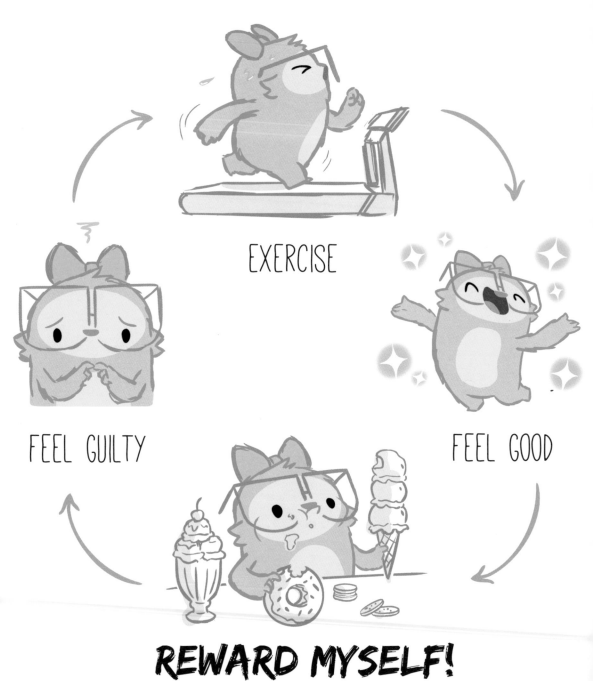

EXERCISE

FEEL GOOD

REWARD MYSELF!

FEEL GUILTY

I USE MY TREADMILL EVERY DAY.

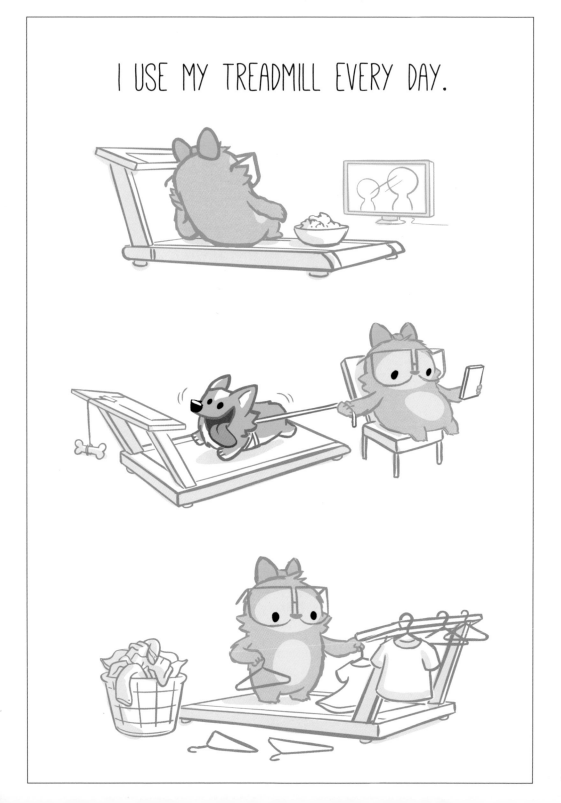

BENEFITS OF YOGA

INCREASED RANGE OF MOTION

TIGHTER GLUTES

STRONGER CORE

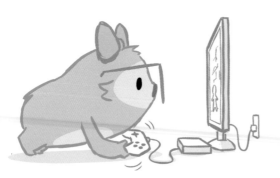

IMPROVED FLEXIBILITY

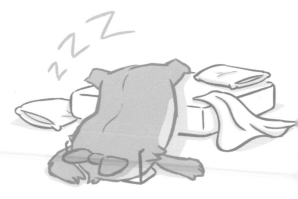

FIRST DAY OWNING A FOAM ROLLER:

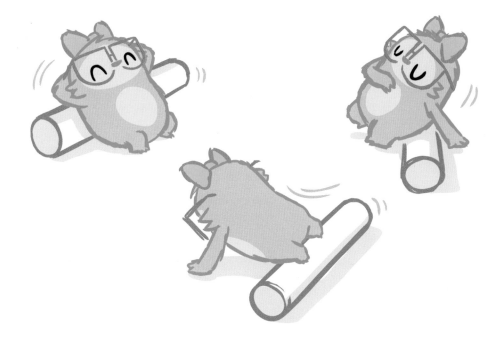

SECOND DAY, AND EVERY DAY AFTER:

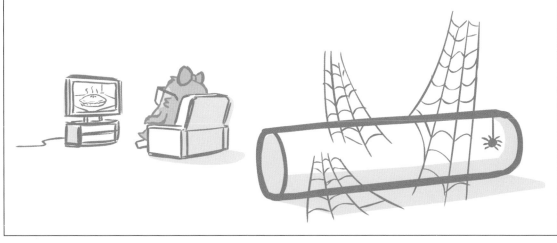

JANUARY 1
FINALLY MADE IT TO THE GYM.

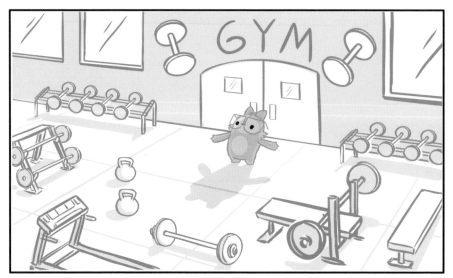

JANUARY 2
BE BACK IN SIX MONTHS.

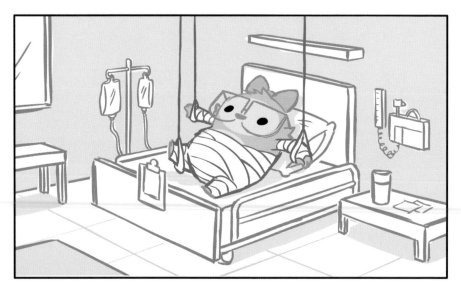

I HAVE ACHIEVED RUNNER'S HIGH!

A MIX BETWEEN NAUSEA
AND ACCOMPLISHMENT.

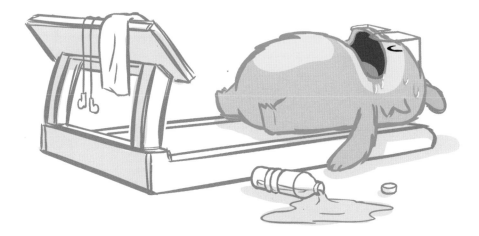

I'M WORKING ON MY SIX-PACK.

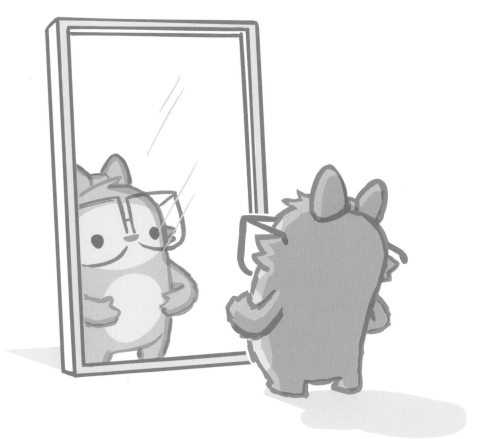

ONLY FIVE MORE PACKS TO GO.

EXERCISE BALL: ALTERNATIVE USES

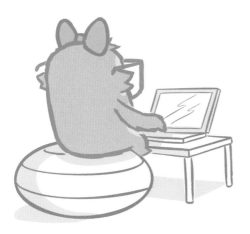

CHAIR

PILLOW

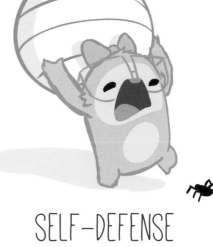

FOOTREST

SELF-DEFENSE

MUST...GET...FIT!

RATHER GET CUPCAKES.

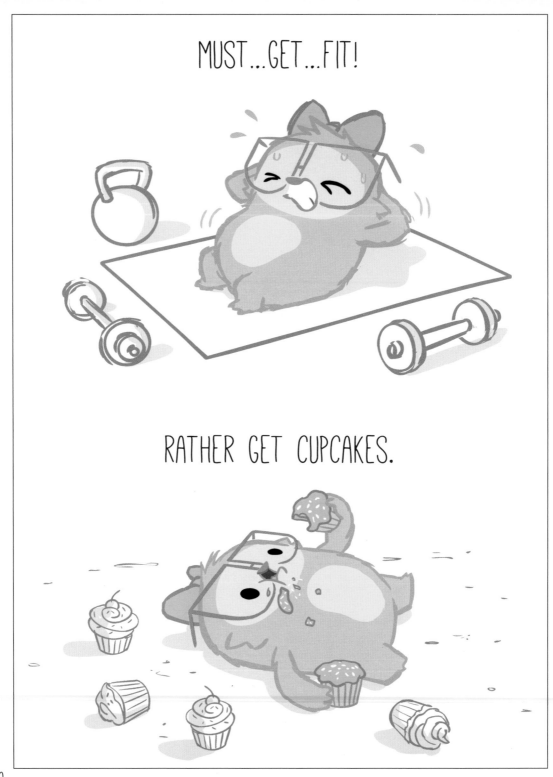

MY FAVORITE YOGA POSES

DOWNWARD DOG

WARRIOR

COBRA

SLOTH

GIMME A SEC.

I'M TRYING TO COUNT MY CALORIES.

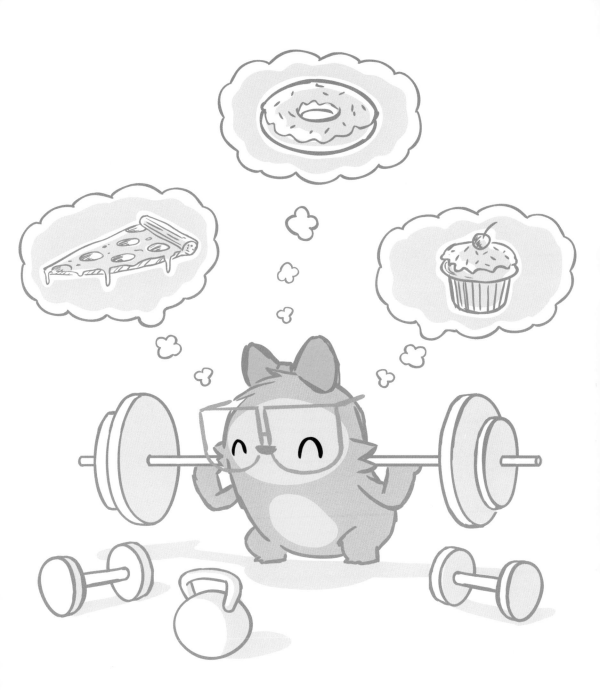

WORK OUT TO EAT OUT.

A CALORIE BURNED...

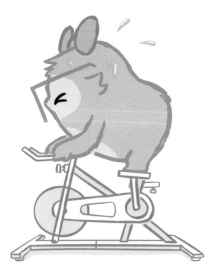

...IS A CALORIE EARNED.

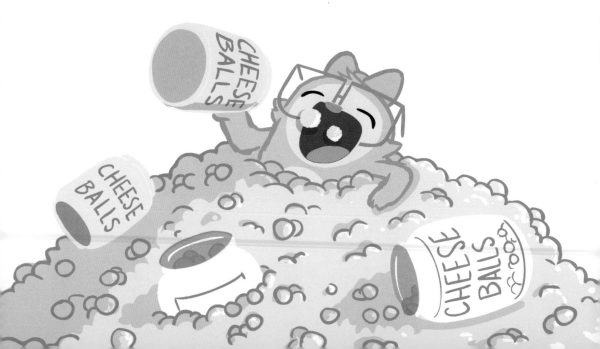

I GOT THIS. I GOT THIS.

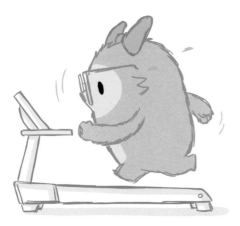

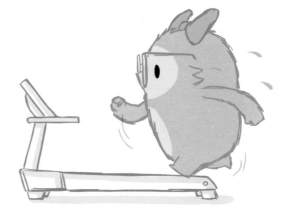

I DON'T GOT THIS.

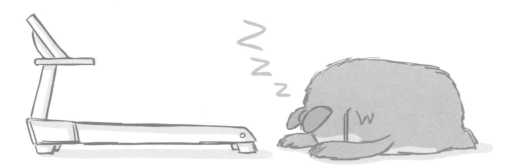

FOOD

NOT SURE IF I'M HUNGRY OR JUST BORED.

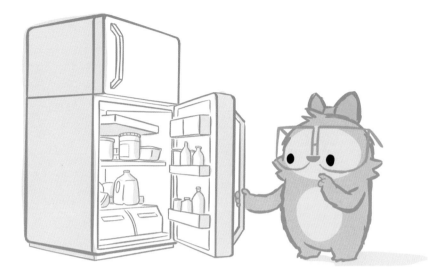

EITHER WAY, PROBLEM SOLVED!

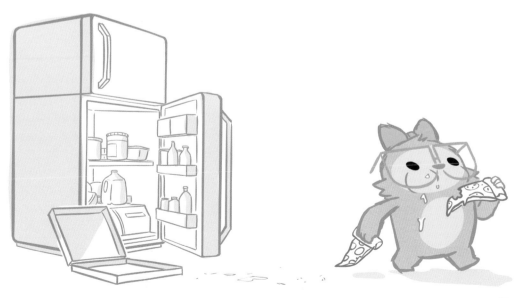

THE MUNCHIES ARE A MANIFESTATION
OF MY ANXIETY.

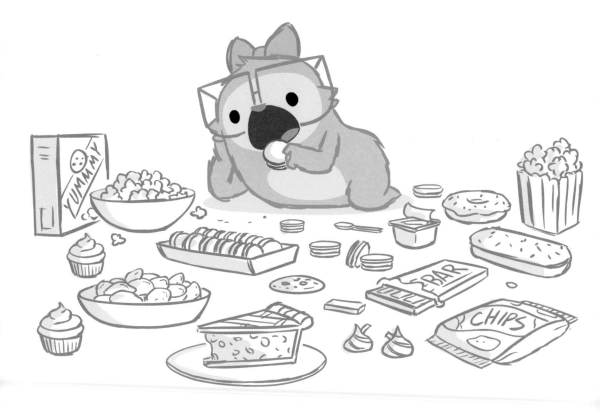

I DON'T WANNA HYDRATE,

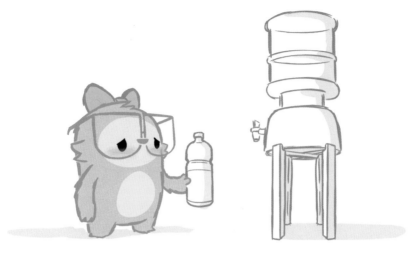

I WANNA CARBOHYDRATE.

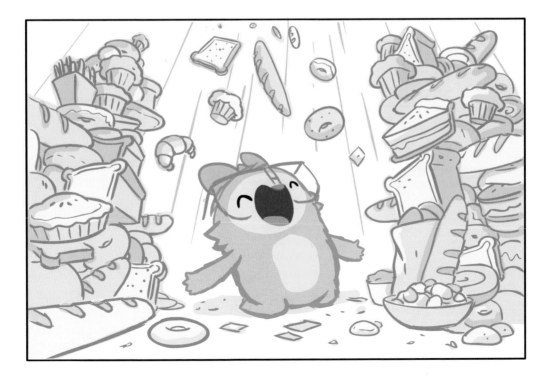

LEAVE ME ALONE.

I'M TESTING FOR LACTOSE INTOLERANCE.

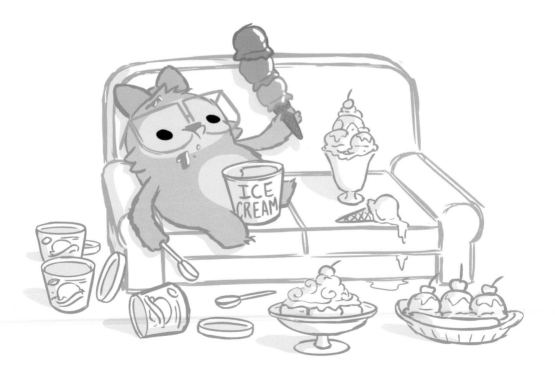

HEALTHY NUTS

CASHEW NUTS

WALNUTS

PINE NUTS

PEANUTS

DOUGHNU...

BURNING CALORIES

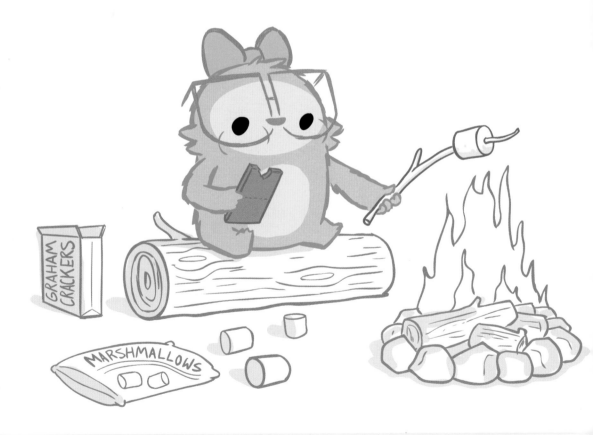

HOW TO MAKE A SMOOTHIE

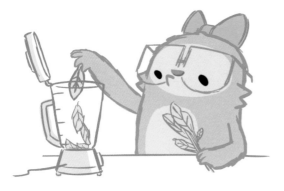

1. LEAFY GREENS

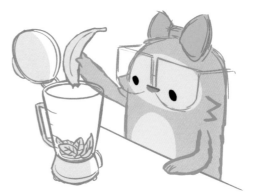

2. A BANANA

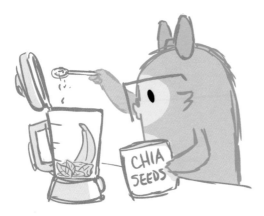

3. CHIA SEEDS?

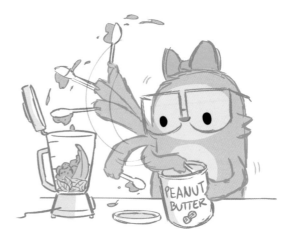

4. PEANUT BUTTER.
LOTS OF PEANUT BUTTER.

MAINLY JUST PEANUT BUTTER.

IT'S FINE...

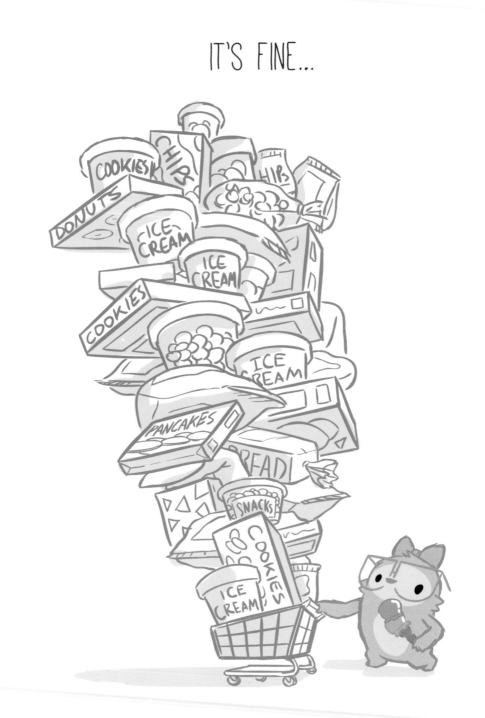

...THEY'RE ORGANIC.

I KEEP TEMPTATION AT A DISTANCE,

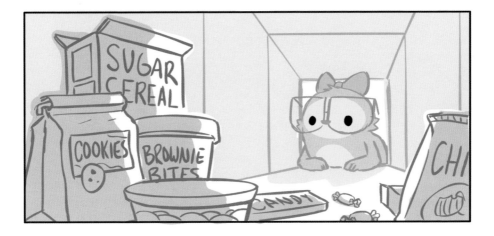

BUT MY STEP-STOOL NEARBY.

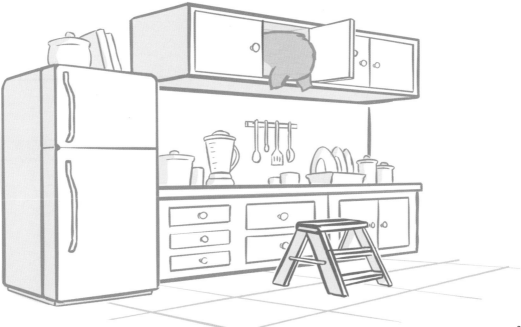

HAMBURGERS WILL ALWAYS HOLD
A SPECIAL PLACE IN MY HEART,

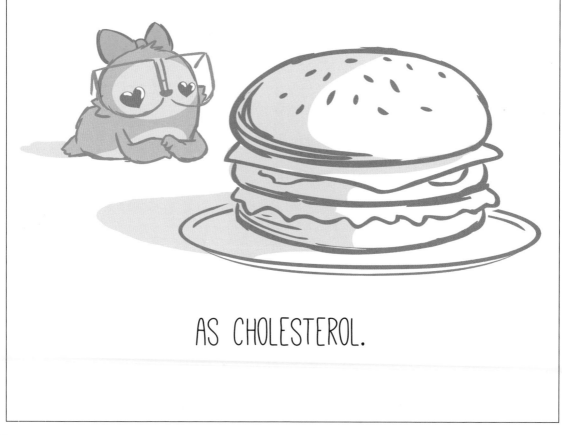

AS CHOLESTEROL.

I'LL SAVE HALF FOR LATER...

...5 <u>MINUTES</u> LATER!

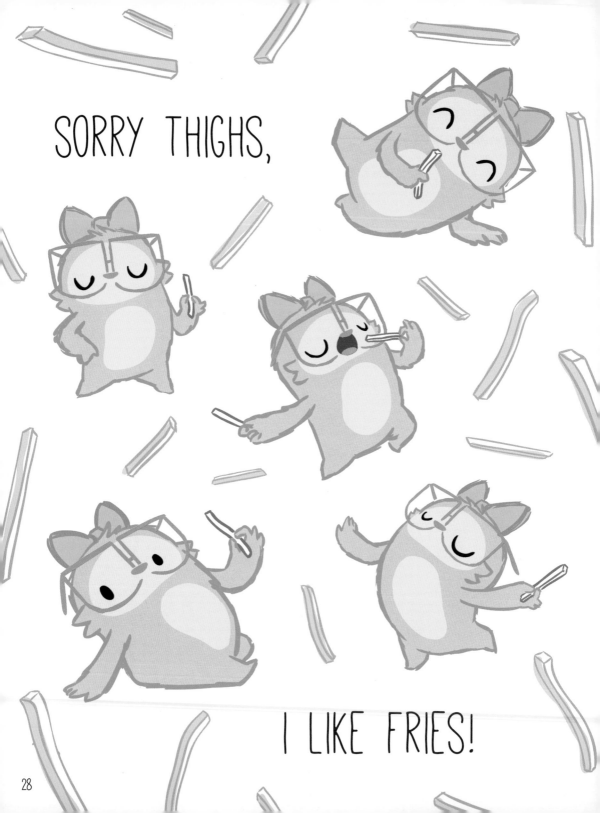

SORRY THIGHS,

I LIKE FRIES!

SELF-CONTROL?

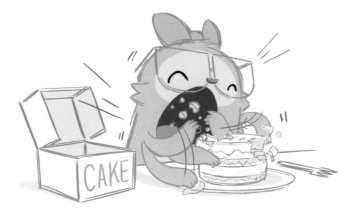

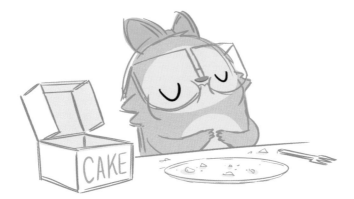

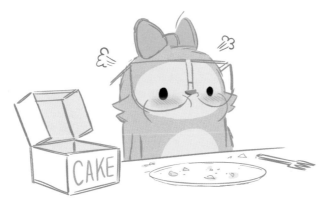

I'M ONLY FAMILIAR WITH INSTANT REGRET.

JUST ONE BITE...

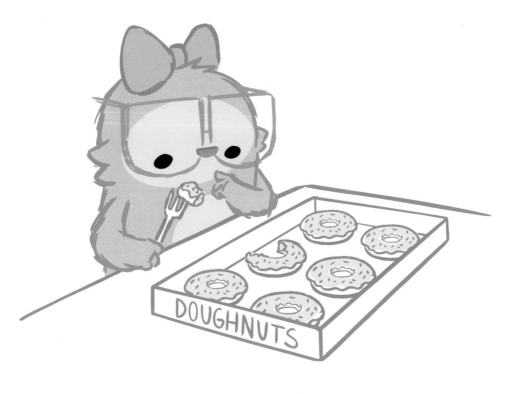

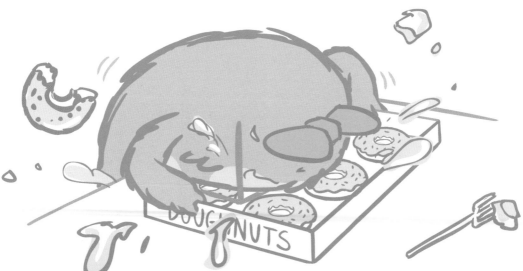

I LOVE BROCCOLI.

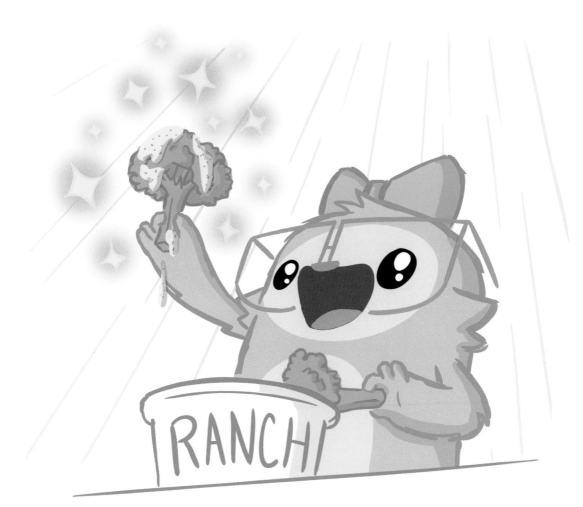

IT ABSORBS THE MOST RANCH.

BREAKFAST,

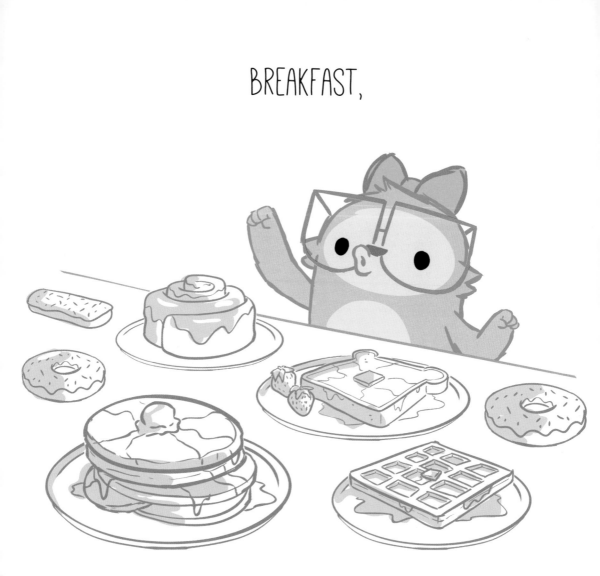

JUST AN EXCUSE TO EAT DESSERT
IN THE MORNING.

CHEAT DAY

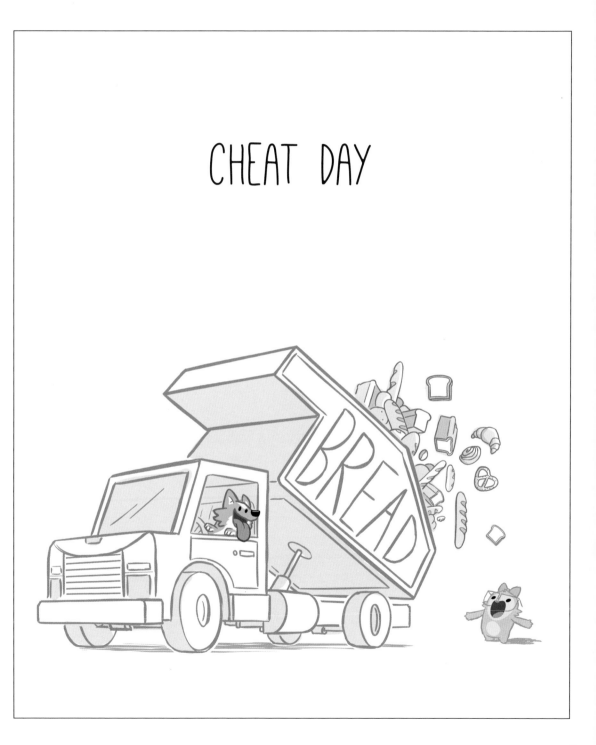

WORK

EVERYTHING'S FINE.

EXCEPT IT'S MONDAY.

THE 4 STAGES OF WRITER'S BLOCK

1. CONCERN

2. WORRY

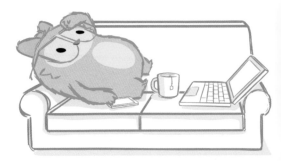

3. DESPAIR

4. ACCEPTANCE

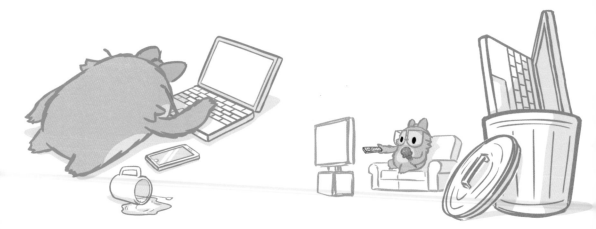

MY DAILY ROUTINE:

☑ MAKE COFFEE

☑ PREP MEALS

☑ EXERCISE

☑ WALK DOG

☑ CLEAN HOUSE

✗ WORK

THE "I DESERVE" TRAP

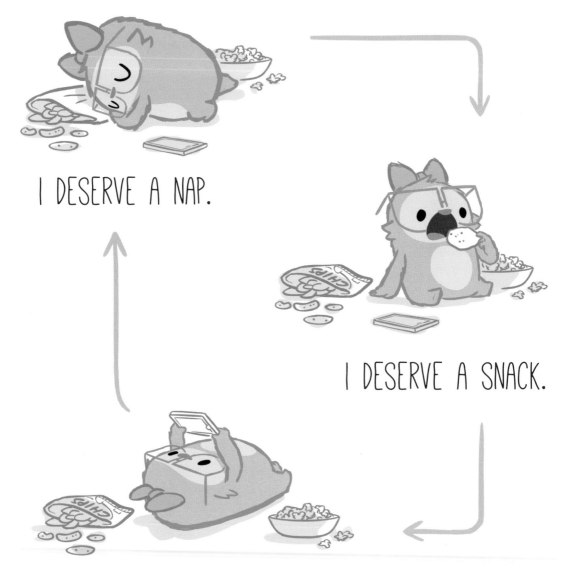

I DESERVE A NAP.

I DESERVE A SNACK.

I DESERVE A BREAK.

WORK HARD,

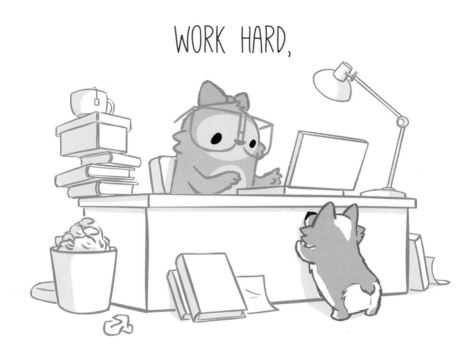

PLAY HARD.

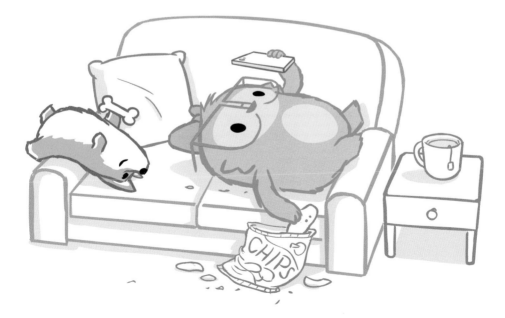

I'M GONNA STOP PROCRASTINATING...

...RIGHT AFTER THIS NAP.

ERGONOMIC WORKSTATIONS

GOOD

BETTER

BEST

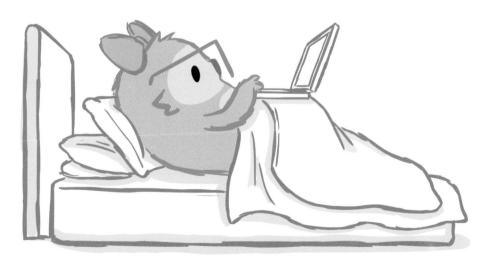

HELP! I'M DROWNING IN WORK!

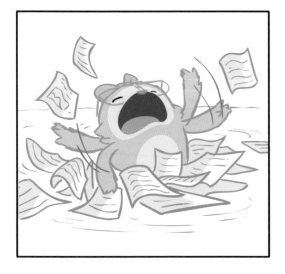

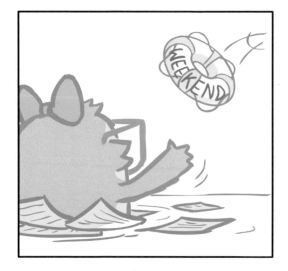

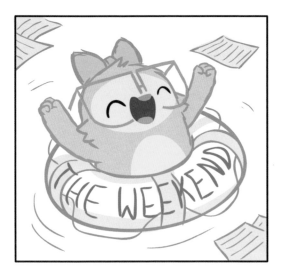

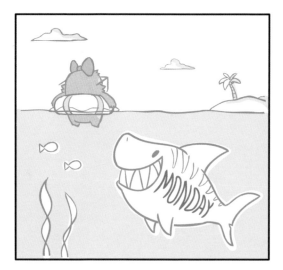

PRODUCTIVE FROM THE FRONT.

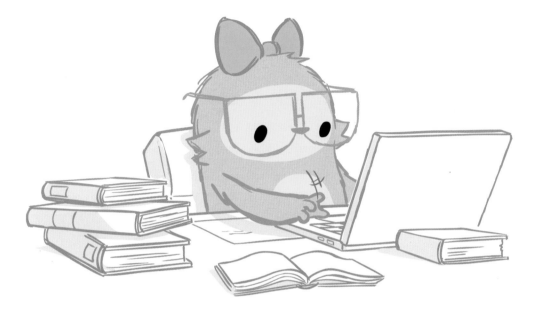

RETAIL THERAPY FROM THE BACK.

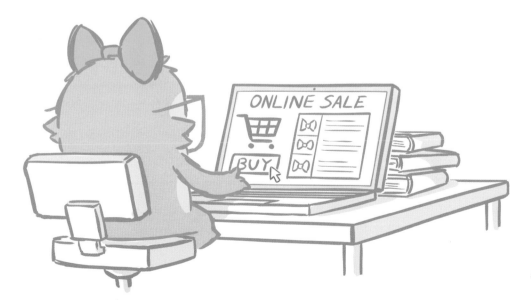

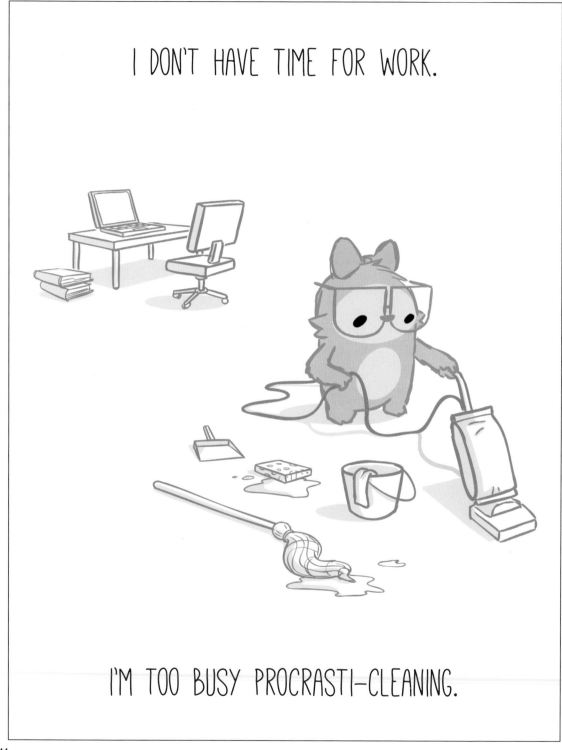

I HAVE A LOVE/HATE RELATIONSHIP
WITH THE INTERNET.

THOUGH MOST OF THE TIME I CHOOSE LOVE!

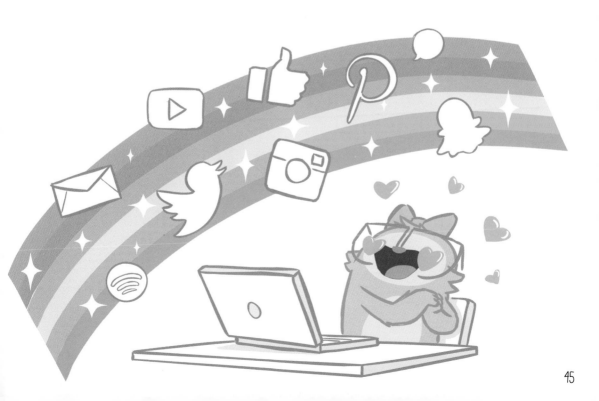

WORK STARTS IN 5 MINUTES,

WHICH MEANS I'VE STILL GOT 4.

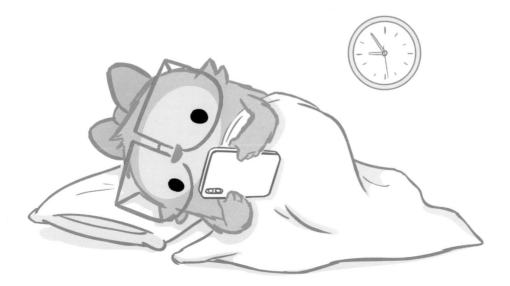

MONEY

I NEVER PAY FULL PRICE...

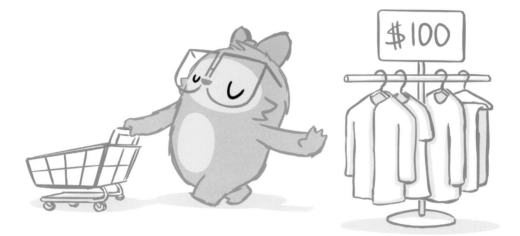

...CUZ I CAN'T AFFORD TO.

WHAT CLEANING OUT THE FRIDGE LOOKS LIKE:

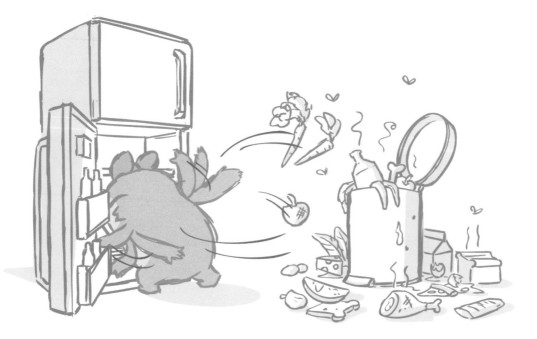

WHAT IT FEELS LIKE:

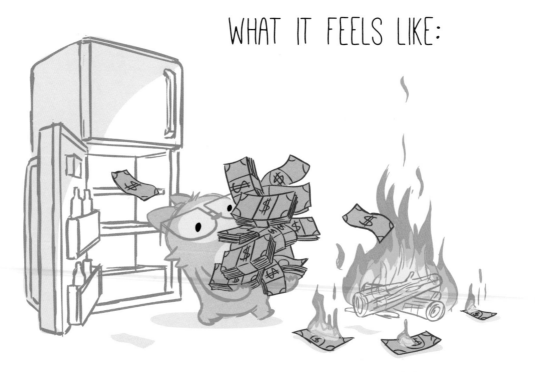

I'M ALL ABOUT DIY PROJECTS...

...CUZ I LIKE TO SAVE MONEY.

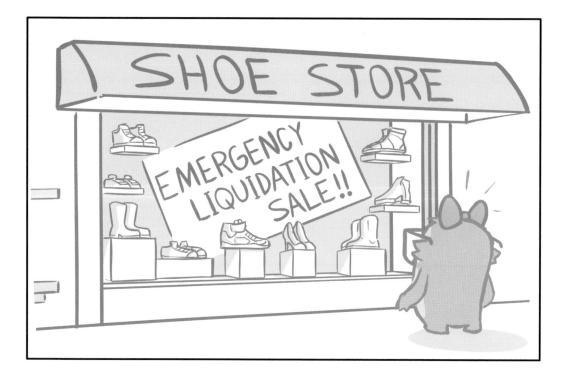

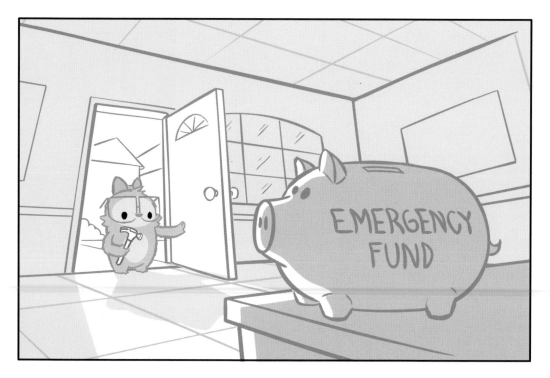

AHH! JUST SPENT THE WHOLE DAY SHOPPING.

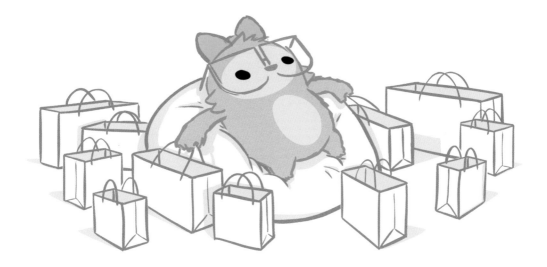

NOW ONTO SOME MUCH NEEDED R&R.

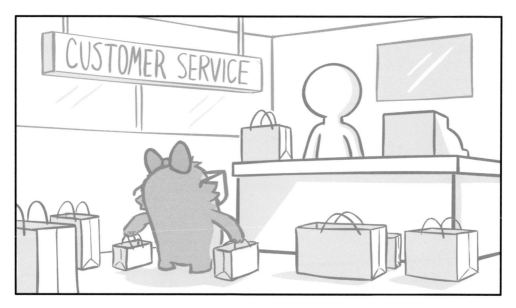

REGRET & RETURN.

I AM DETERMINED, AND I WILL FIND YOU...

...VALID ONLINE COUPON CODE.

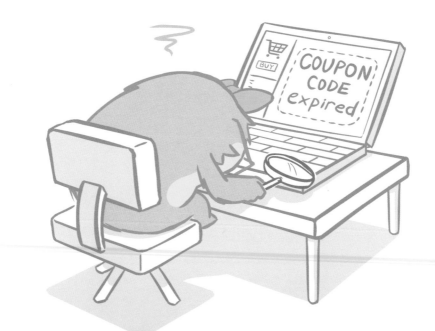

I SHOULD BUY SOME FRUIT.

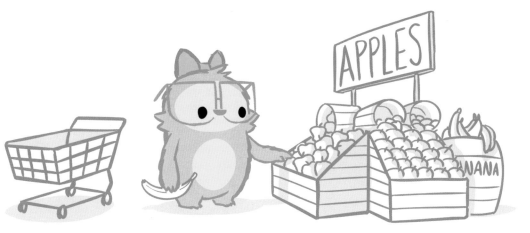

I'LL EAT IT EVENTUALLY.

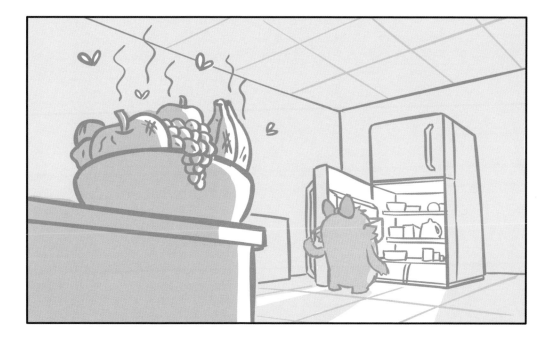

A WALLET FILLED WITH CREDIT CARDS ISN'T IRRESPONSIBLE.

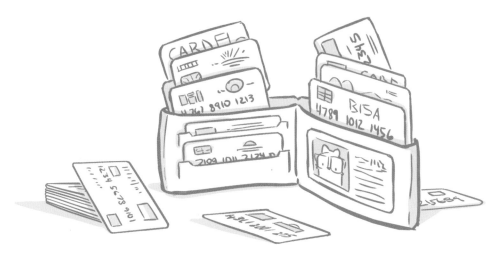

IT'S RESOURCEFUL!

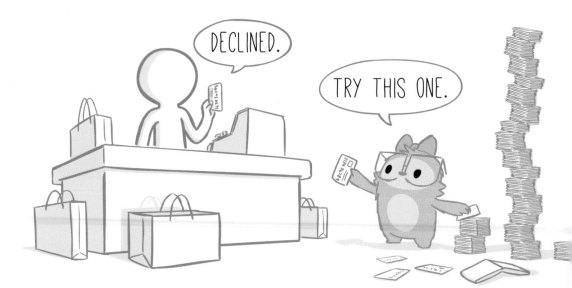

ORDERED A GIFT FOR MY FRIEND,

AND A FEW THINGS FOR MYSELF.

LAST ONE? AND IT'S ON SALE!?

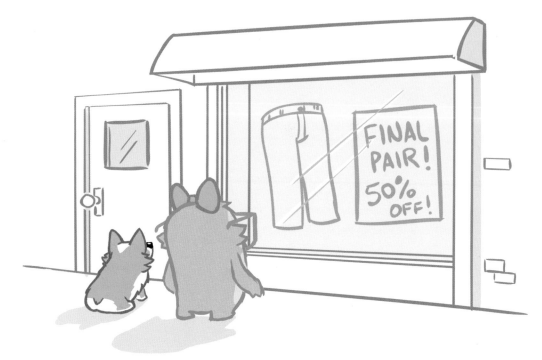

I'LL GROW INTO IT.

HOME

MY HOUSE IS TIDY.

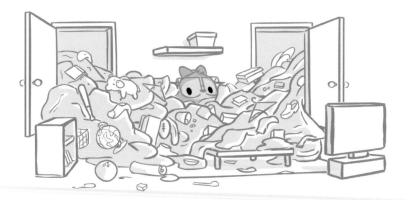

I DIDN'T SAY IT WAS ORGANIZED.

CAN'T GET OUT OF BED,

TO-DO LIST WEIGHING ME DOWN.

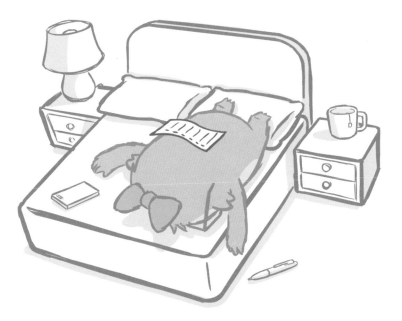

PEOPLE CALL IT A DISASTER ZONE.

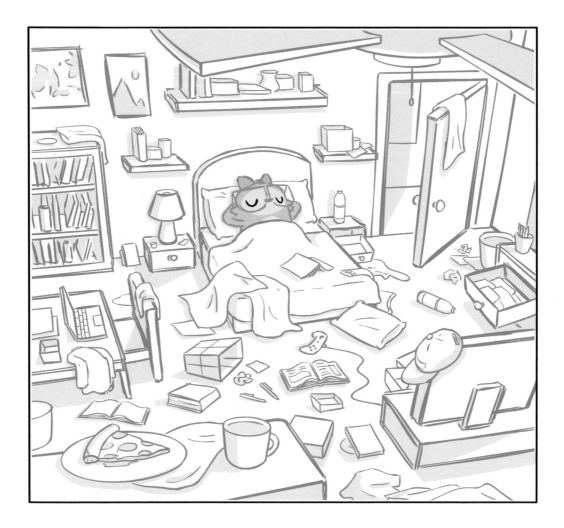

I CALL IT MY COMFORT ZONE.

LOOK AT ALL THE BOOKS I OWN.

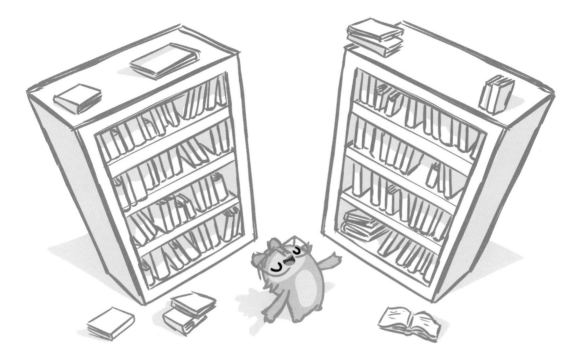

THESE ARE MY FAVORITES.

I LIVE LIFE ON THE EDGE...

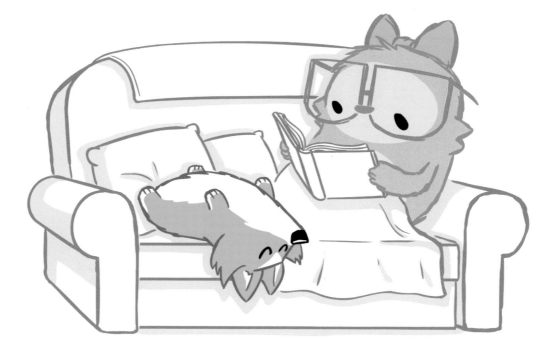

...OF MY COUCH.

BRACE YOURSELF;
LAUNDRY DAY
IS COMING.

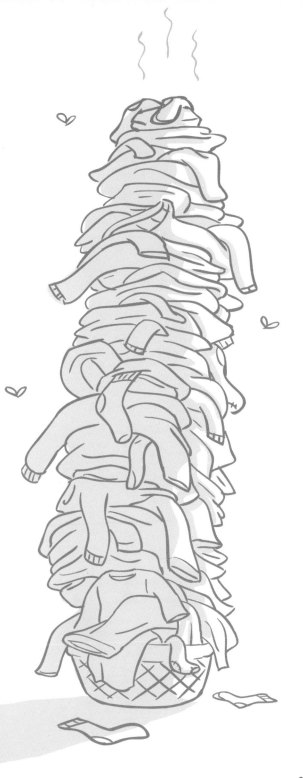

JUST...ONE...LOAD!

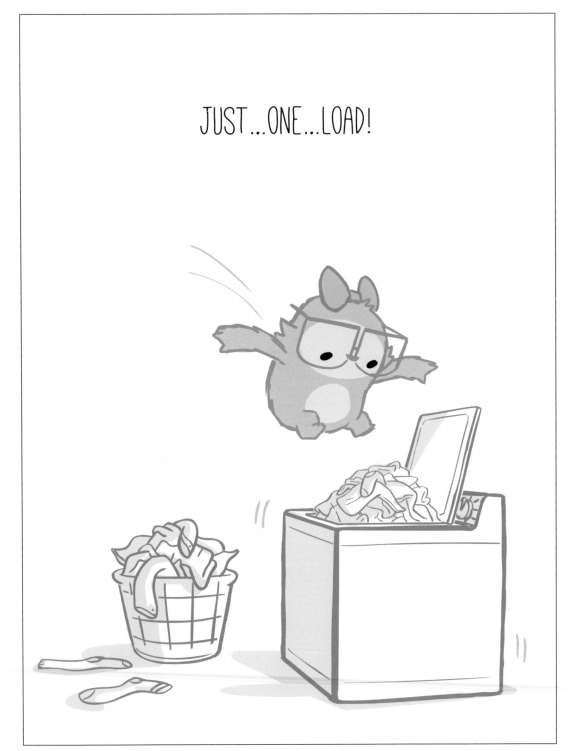

SSHHHH.

I'M TRYING TO PROCRASTI-NAP.

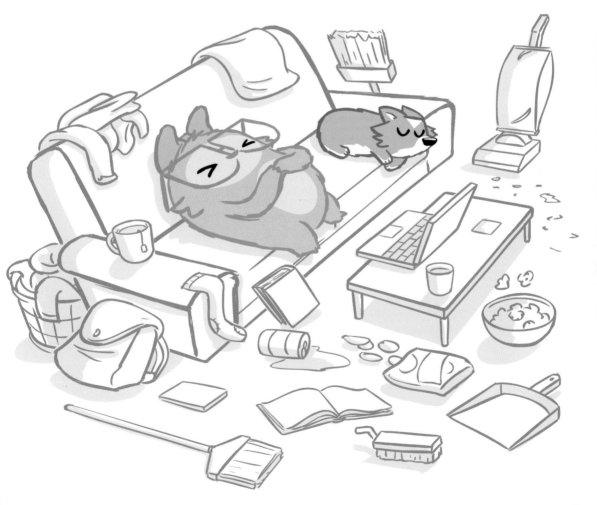

I MADE MY BED,

NOW I MUST LIE IN IT!

NAILED IT!

MY ROOM IS A SAFE SPACE,

BUT PLEASE, PROCEED WITH CAUTION.

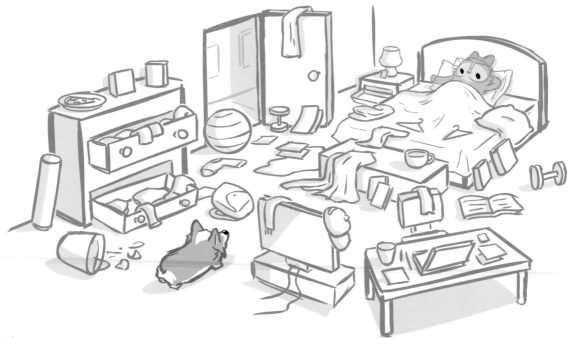

MY REFRIGERATOR:

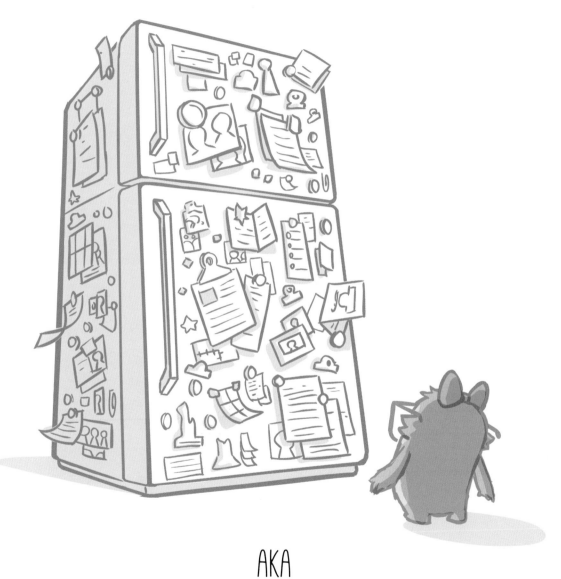

AKA

"THE OTHER JUNK DRAWER."

WHEN LIFE GIVE YOU LEMONS

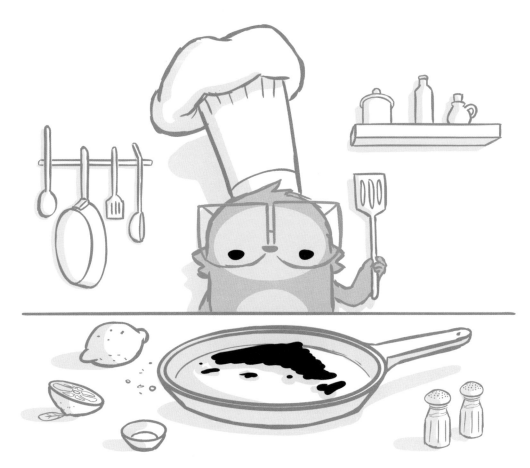

JUST EAT THE LEMON
CUZ COOKING IS HARD.

SAVING PLASTIC CONTAINERS:

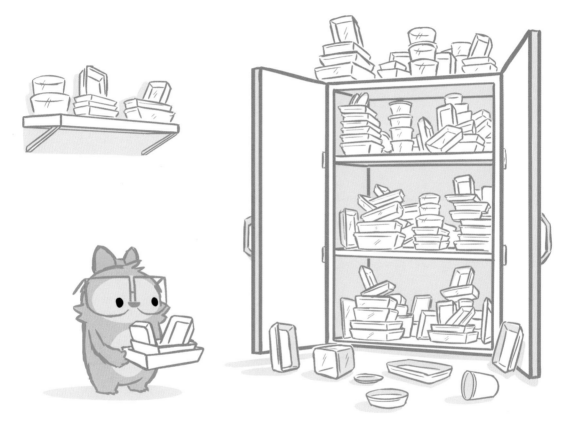

THE FINE LINE BETWEEN
ENVIRONMENTALISM AND HOARDING.

I MADE EM FROM SCRATCH.

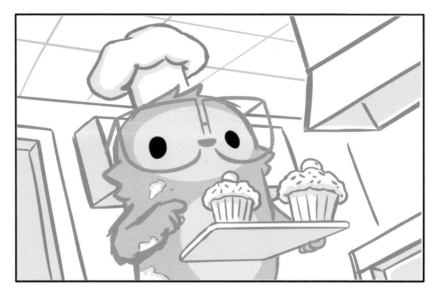

WORTH IT.

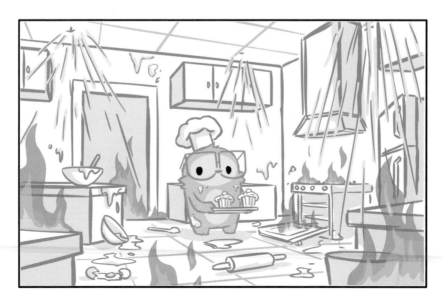

LIFESTYLE

SEASONAL VIBES

SUMMER

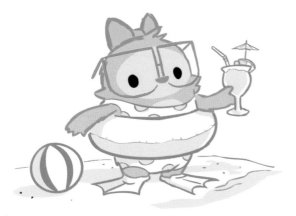

FALL

WINTER

SPRING

#VACATION

MY SUPERPOWER IS...

...POWER NAPPING.

THE SELFIE CYCLE

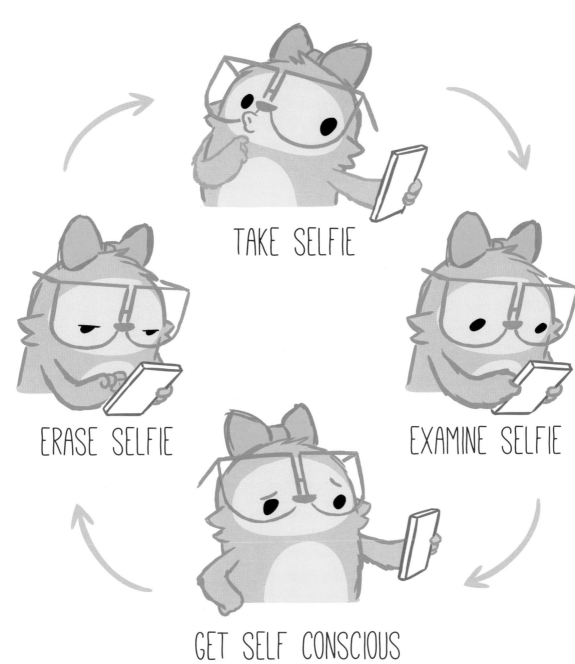

TAKE SELFIE

EXAMINE SELFIE

GET SELF CONSCIOUS

ERASE SELFIE

MY AUTHENTIC SELF IS
A COUCH POTATO.

TIME FOR MY BEAUTY REST.

(6 HOURS LATER)

OKAY, I'M ALL PACKED...

...FOR MY WEEKEND TRIP.

GOING TO THE BEACH IS NICE.

I GET TO WORK ON MY TAN.

SEARCHING FOR INNER PEACE.

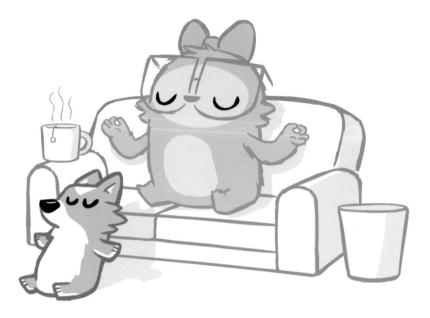

MAYBE I'LL FIND IT WHEN I WAKE UP.

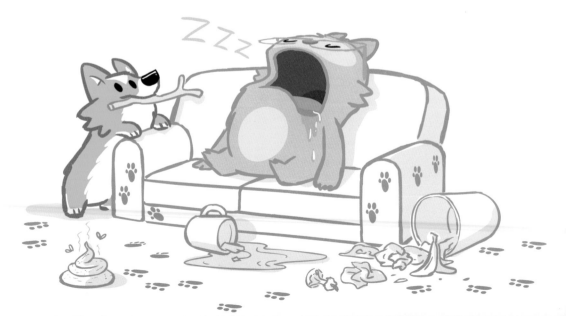

MY KINDA PARTY

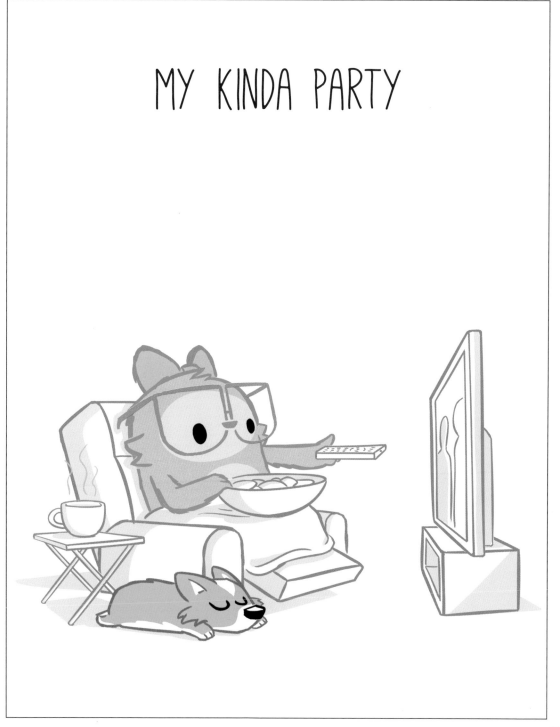

HOW TO TOLERATE LIFE

1. GET COFFEE

2. DRINK COFFEE

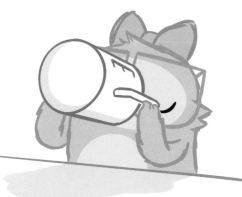

3. ENJOY SUPERPOWERS

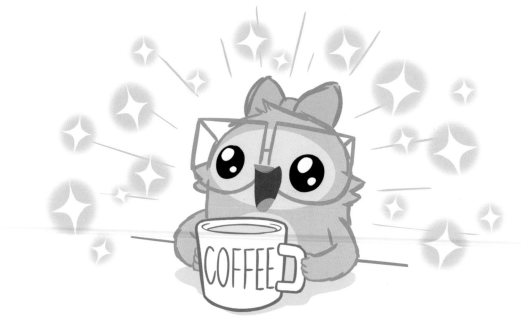

PLEASE EXCUSE ME,

I'M INTROVERTING.

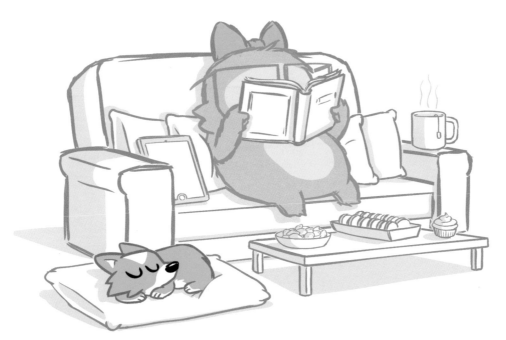

I'M GONNA DO CARDIO TOMORROW,

BUT TODAY I'M DOING HEAVY LIFTING.

MY FAVORITE KIND OF LUNCH IS...

...BY MYSELF.

#LIFE

MY FAVORITE TIME IS...

...ME-TIME.

PATIENCE IS A VIRTUE.

UNLESS I'M HUNGRY,

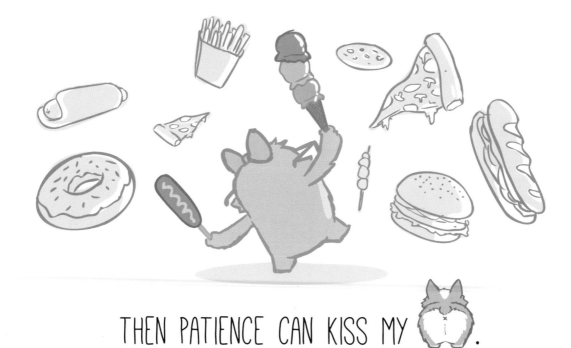

THEN PATIENCE CAN KISS MY .

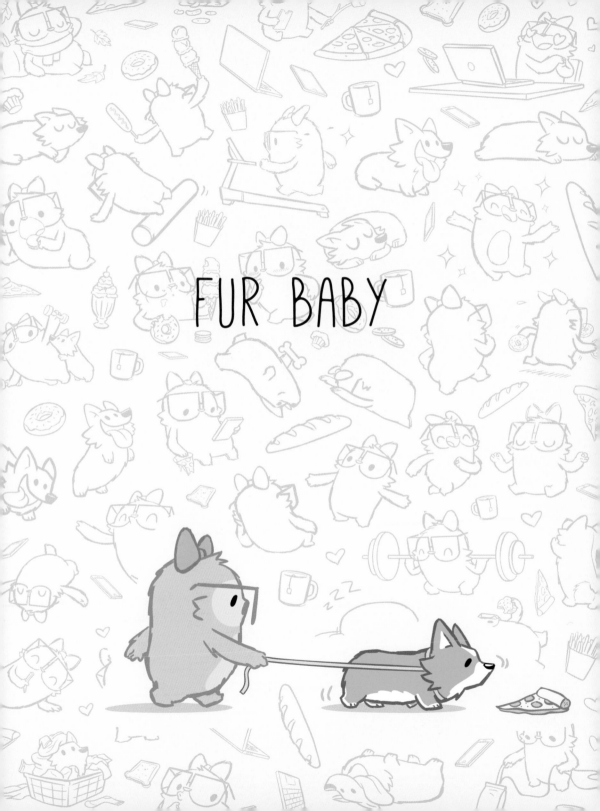

FUR BABY

MY LIFE, INTERRUPTED

EXERCISING

EATING

CHANGING

CLEANING

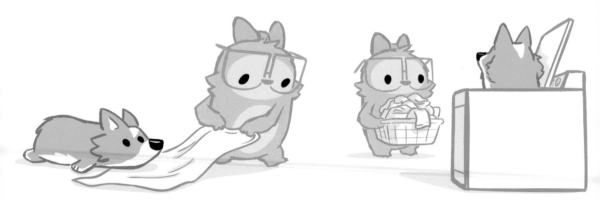

MY DOG LOOKS SO CUTE WHEN HE SLEEPS.

I'LL TRY NOT TO WAKE HIM UP.

DOGGY LANGUAGE

LOVE ME.

LOVE ME.

LOVE ME.

GO AWAY.

MY DOG, MASTER OF DISGUISE.

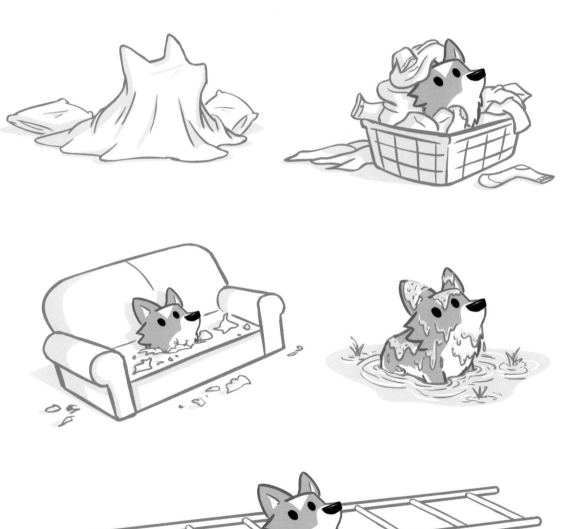

I LOVE FIREWORKS.

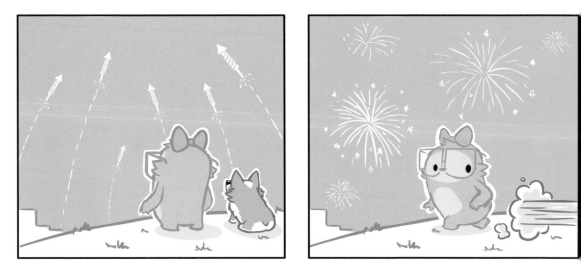

PEANUT DOES NOT.

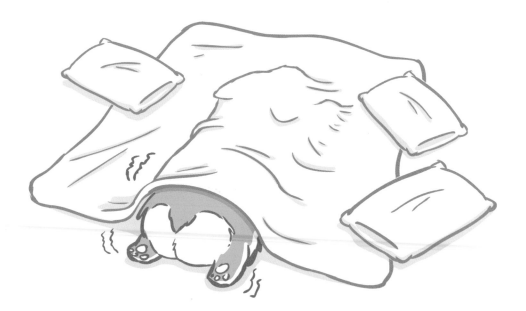

THE GRASS IS GREENER ON THE OTHER SIDE.

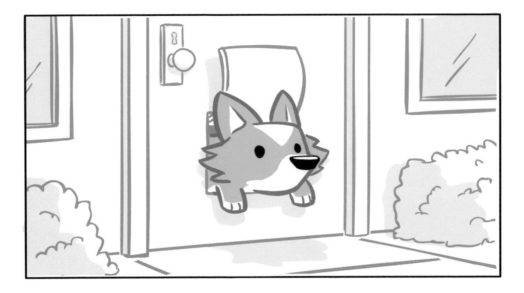

I JUST NEED HELP GETTING THERE.

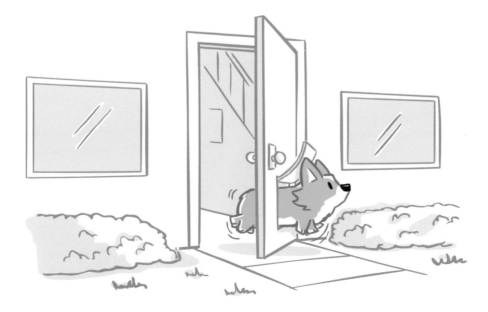

I CAN EXPLAIN EVERYTHING.

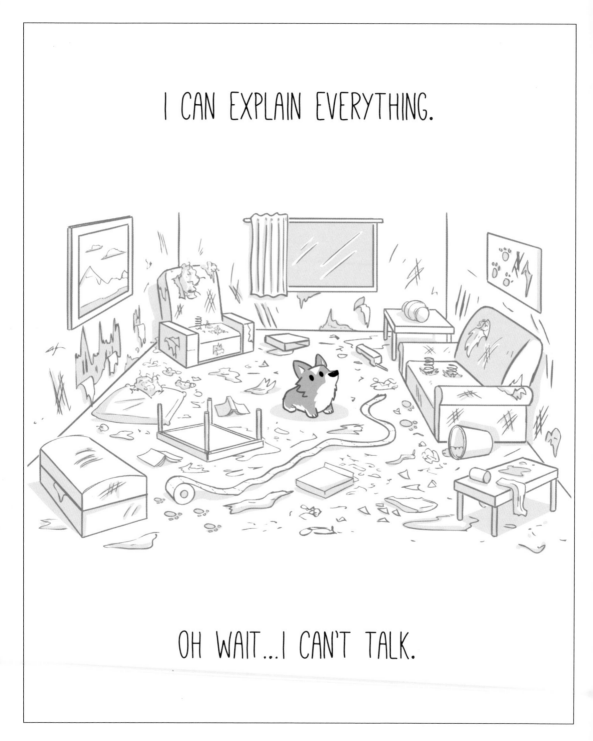

OH WAIT...I CAN'T TALK.

LET'S GO HALVSIES.

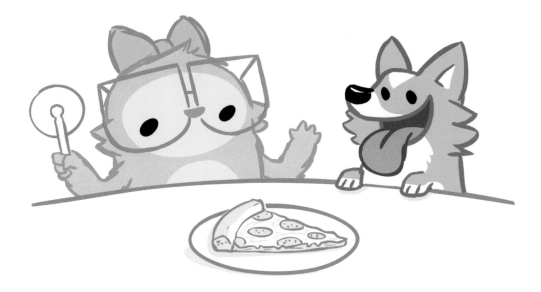

THAT'S NOT WHAT I HAD IN MIND.

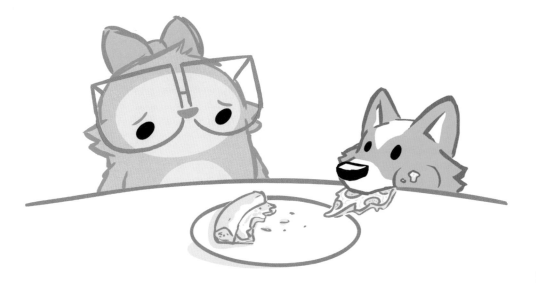

BAD HAIR DAY?

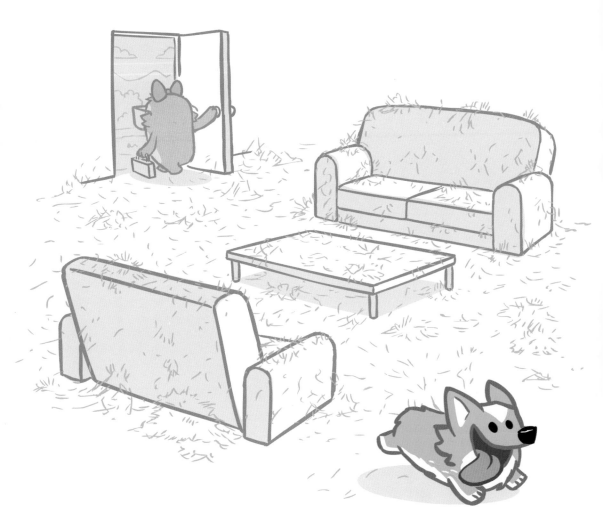

HERE IT'S CALLED <u>EVERY</u> DAY.

PEANUT'S A SPECIAL DOG.

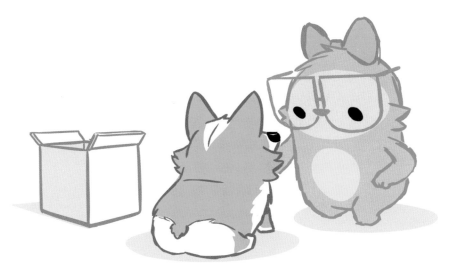

HE KNOWS HOW TO THINK OUTSIDE THE BOX.

MY DOG, THE PICKY EATER.

I BOUGHT YOU A GIFT, PEANUT!

A LITTLE GRATITUDE WOULD BE NICE.

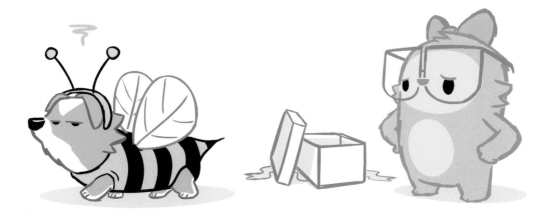

MY OTHER ALARM CLOCK.

I'M HOME!

DID YOU MISS ME?

I LOVE YOU, PEANUT...

...EVEN THOUGH I'M YOUR #2.

THE END

GRATITUDE

Completing this book was no easy task. Turns out writing/illustrating a book about the sloth life isn't exactly conducive to actually living the sloth life. Thankfully, I had a slew of people to push me along the way.

First and foremost, thank you to Mark Gottlieb, my agent at Trident Media, who discovered my work and decided that creating a book would be a good idea. Thank you Mark, for helping me bring this book to fruition!

To Leah Zarra, my editor, and the team at Skyhorse Publishing. You guys took a chance on me and have been nothing but encouraging throughout this process. Thank you for believing enough in my work and for providing me with the resources to become an actual published author!

To Dr. Nadine Macaluso, my Jedi master, for teaching me about authenticity, agency, and for helping me develop a level of courage within myself that I would've never discovered on my own.

To Mary Lang, my book publishing mentor. Thank you for being my guiding light since the very beginning, and for helping me navigate this project in the right direction.

To my friends and family members. Specifically: Dad, Sass, Lindy, Nick Chelyapov, Paul Yoshida, Benjamin Kaltenecker, Bradford Gibbons, the Villoria family, Jess Gilliam, and the folks over at Giphy. This book would've never been made possible if it weren't for you guys. You were all pivotal in inspiring, influencing, and pushing me along the way.

To the most important person in my life, my wife, K.C., whom I love more than anything else in this world (even more than churros). Thank you for supporting this crazy dream of mine to make comics about a quirky little sloth. Slothilda wouldn't be nearly as funny and lovable if it weren't for you. I'm so lucky to have you in my life.

To my social media friends and e-mail subscribers, I love you guys! I am beyond grateful to have such a strong fan base of fellow sloths. Thanks for keeping me motivated all these years, and for your never-ending love and support. I look forward to sharing new Slothilda comics with you online.

Lastly, a ginormous thanks to you, the reader. I hope you enjoyed this book. Got any questions, comments, or suggestions? Feel free to drop me a line by writing in from slothilda.com, or feel free to say hi on Twitter or Instagram (@slothilda).

—Dante Fabiero

ABOUT THE AUTHOR

Dante Fabiero is a Los Angeles native who has made a career working on some of TV's most popular animated shows, seen on Netflix, TBS, and Fox. Fabiero launched Slothilda in 2014 and has garnered close to half a billion views on the website Giphy. You can see Slothilda come to life and subscribe to receive future comics for free at slothilda.com.

@slothilda

@slothilda

slothilda.sloth

WWW.SLOTHILDA.COM

Skyhorse Publishing books may be purchased in bulk at special discounts for sales promotion, corporate gifts, fund-raising, or educational purposes. Special editions can also be created to specifications. For details, contact the special sales department, Skyhorse Publishing, 307 West 36th Street, 11th Floor, New York, NY 10018 or info@skyhorsepublishing.com.

Skyhorse® and Skyhorse Publishing® are registered trademarks of Skyhorse Publishing, inc.®, a Delaware corporation.

Visit our website at www.skyhorsepublishing.com.

10 9 8 7 6 5 4 3 2 1

Library of Congress Cataloging-in-Publication data is available on file.

Cover design by Jenny Zemanek
Cover illustration by Dante Fabiero

Print ISBN: 978-1-5107-3657-3
eBook ISBN: 978-1-5107-3660-3

Printed in China